HULL

HISTORY TOUR

For Geoff Chalder, Ian Dickson and Alan Lund – Nicholson Hall,
The Lawns, 1973–76, again

First published 2018

Amberley Publishing
The Hill, Stroud,
Gloucestershire, GL5 4EP
www.amberley-books.com

Copyright © Paul Chrystal, 2018
Map contains Ordnance Survey data
© Crown copyright and database
right [2018]

ISBN 978 1 4456 8237 2 (print)
ISBN 978 1 4456 8238 9 (ebook)

British Library Cataloguing in
Publication Data.
A catalogue record for this book is
available from the British Library.

Origination by Amberley Publishing.
Printed in Great Britain.

ABOUT THE AUTHOR

Paul Chrystal has a Classics degrees from the universities of Hull and Southampton, and he worked as a medical publisher for nearly forty years. He is the author of 100 or so books, many of which are about Yorkshire. He is a regular contributor to a number of history magazines, is a reviewer for 'Classics for All' and he writes for a national daily newspaper. He has appeared on the BBC World Service, Radio 4's PM programme and various BBC local radio stations in York, Manchester, Cleveland and Sheffield. He lived in Hull between 1973 and 1978.

By the same author:
Hull Pubs
Hull in 50 Buildings
Historic England: Hull
Pubs In & Around York
The Place Names of Yorkshire – Including Yorkshire Pub Names
Leeds in 50 Buildings
The Confectionery Industry in Yorkshire
Tadcaster History Tour
Yorkshire Literary Landscapes
Yorkshire Murders, Manslaughter, Madness & Executions
For a full list please visit www. paul.chrystal.com

INTRODUCTION

This book is a guide to the historic splendours of Hull, a city steeped in history and culture, as we clearly saw during 2017 when Hull was a worthy and most impressive City of Culture. This book is designed to slip into your pocket or bag as a quick and handy guide to the outstanding sights of the city. The map will tell you where they all are, the captions will tell you all about them, and the photographs – old and new – will illuminate each sight.

The book is a compilation of material from my *Hull Pubs* and *Hull in 50 Buildings* books, and *Hull Through Time* by the late Philip C. Miles – a greatest hits of all three if you like.

Hull History Tour takes in some of the city's splendid museums, Hull Minster, Trinity House, the docks, the Deep, the Carnegie Library, some of the many ancient pubs, the Reckitt Garden Village, the university and the old docks, a toilet, a wind turbine blade and a phone box – and a lot more besides.

So, take the book with you on your tour of Hull's history – a tour that will not disappoint.

Paul Chrystal, February 2018

KEY

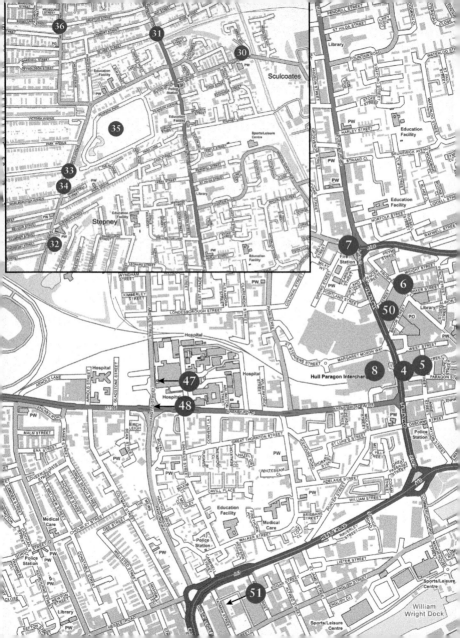

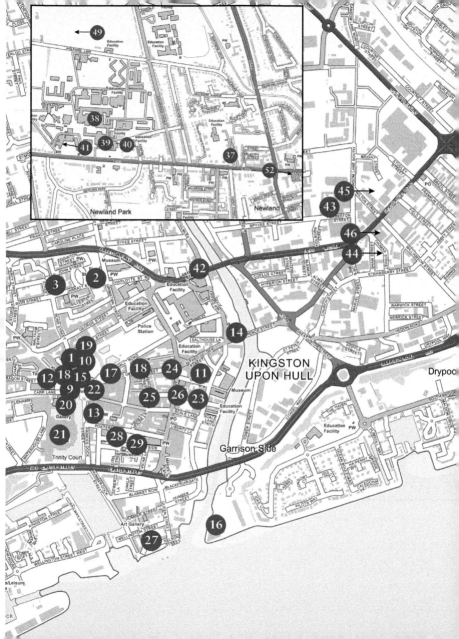

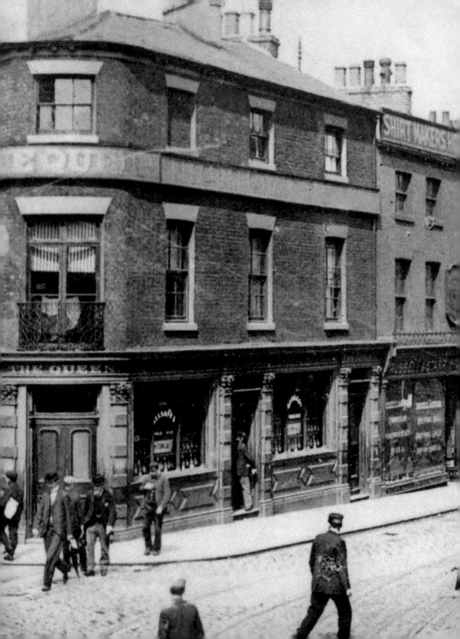

1. THE OLD CITY CENTRE

Much of the old city centre was demolished at the end of the 1890s in preparation for the building of King Edward Street. In this rare photograph taken before the demolition, in the foreground you can see The Queen public house, and in the background is the Lord Londesborough Hotel. The street just visible going off on the right is Savile Street.

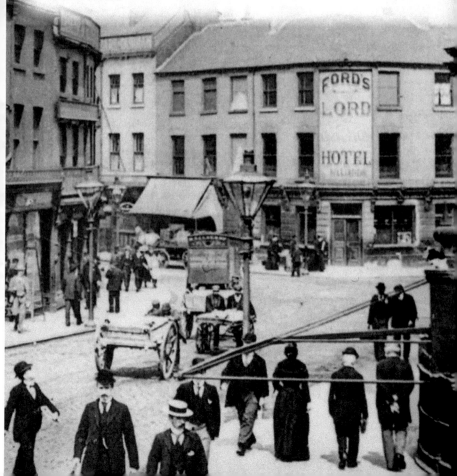

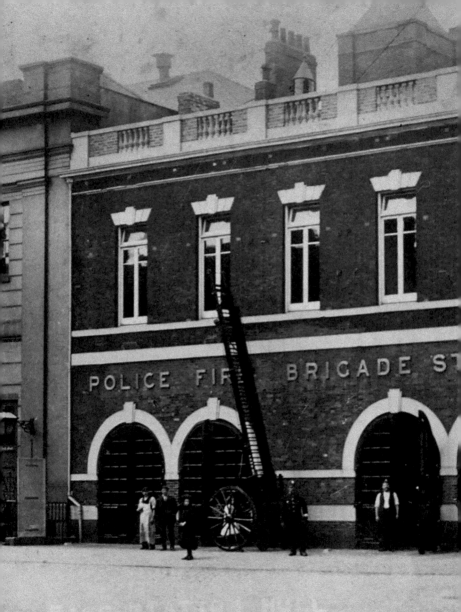

2. HULL CENTRAL FIRE STATION

The central fire station of the Hull fire brigade is at the corner of Worship Street and Jarratt Street. The Hull police force was also stationed in this building. Note the precautionary escape ladder. The Assembly Rooms were next door.

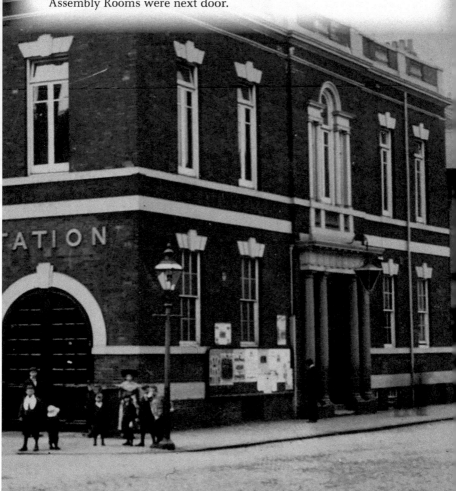

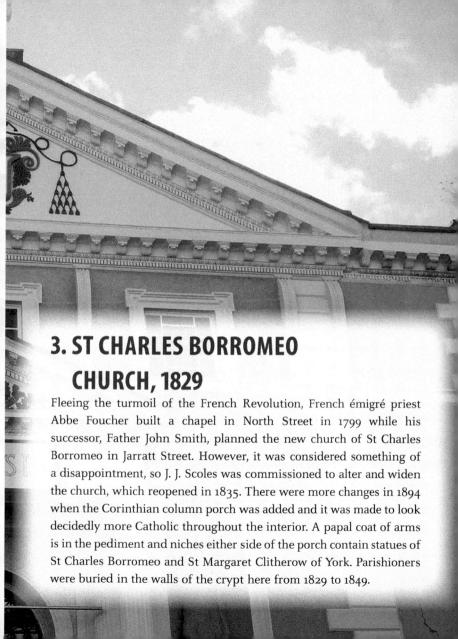

3. ST CHARLES BORROMEO CHURCH, 1829

Fleeing the turmoil of the French Revolution, French émigré priest Abbe Foucher built a chapel in North Street in 1799 while his successor, Father John Smith, planned the new church of St Charles Borromeo in Jarratt Street. However, it was considered something of a disappointment, so J. J. Scoles was commissioned to alter and widen the church, which reopened in 1835. There were more changes in 1894 when the Corinthian column porch was added and it was made to look decidedly more Catholic throughout the interior. A papal coat of arms is in the pediment and niches either side of the porch contain statues of St Charles Borromeo and St Margaret Clitherow of York. Parishioners were buried in the walls of the crypt here from 1829 to 1849.

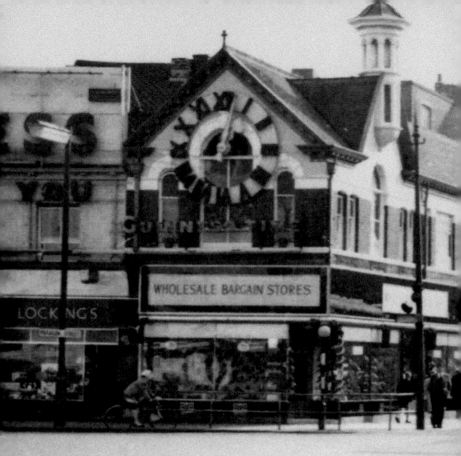

4. THE GUINNESS CLOCK

For many years the Guinness clock was a popular landmark in the city centre above the shops in Paragon Street. The wording to the left of the clock reads, 'Guinness is good for you'. Lockings and the Wholesale Bargain Store are underneath the clock.

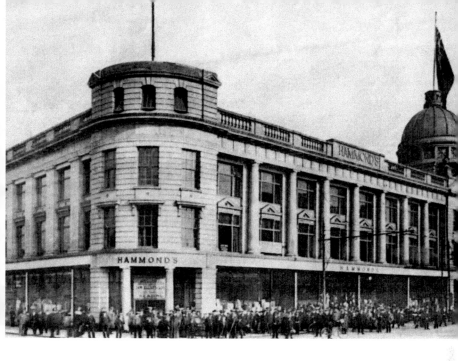

5. HAMMOND'S STORE

The original Hammond's department store in Paragon Square opened in May 1916, replacing an earlier store in Osborne Street. This large, modern-looking store stood here for nearly thirty years until it was destroyed by enemy bombs during the Second World War on 7 August 1942. A new Hammond's store was built on the same site after the war and remains little changed since it was rebuilt. Today, Hammond's is now House of Fraser.

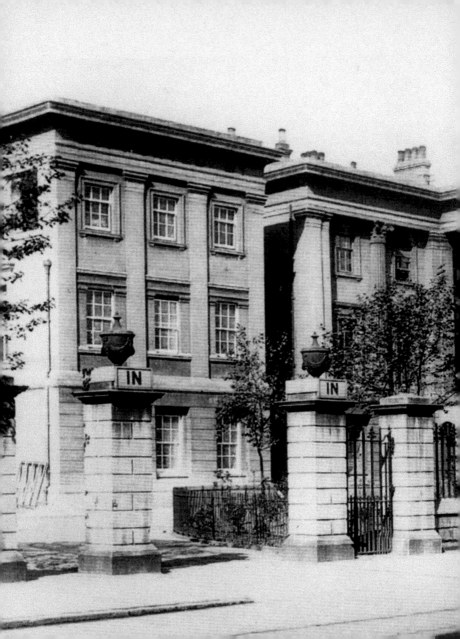

6. THE OLD INFIRMARY

The Infirmary was built in 1784 on what was then called Beverley Road (today this is Prospect Street), when it was surrounded by fields. Further extensions to the Infirmary were added between the 1850s and the 1880s. The name was changed in 1884 to the Royal Infirmary. It was demolished in 1972 and replaced by the Prospect shopping centre.

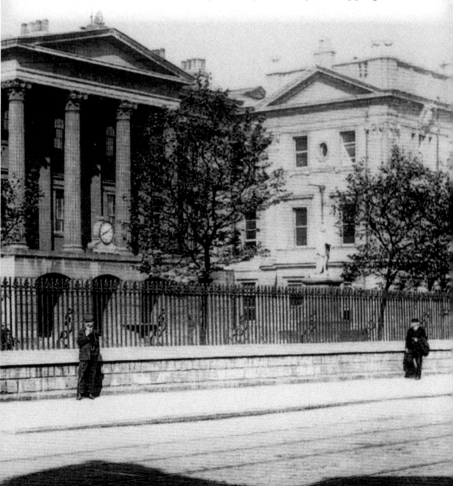

7. BEVERLEY ROAD AND SPRING BANK JUNCTION

There are lots of horse-drawn carts in this photograph taken around 1900. On the left are the works of Blundell, Spence & Co., paint and varnish manufacturers. An electric tram is just visible, passing the Zoological public house. On the right is Marlborough Street. Much of this area was completely destroyed during the Second World War. This junction was for many years known as Blundell's Corner and many people still refer to it as that. The *Hull Daily Mail* offices now stand on the corner.

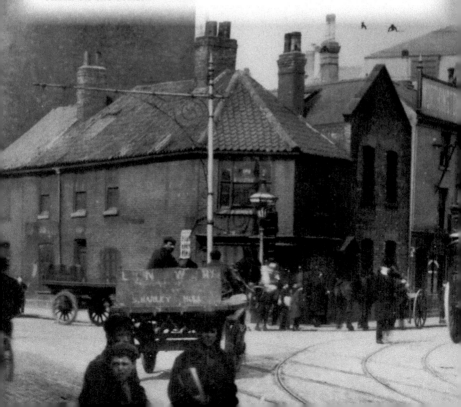

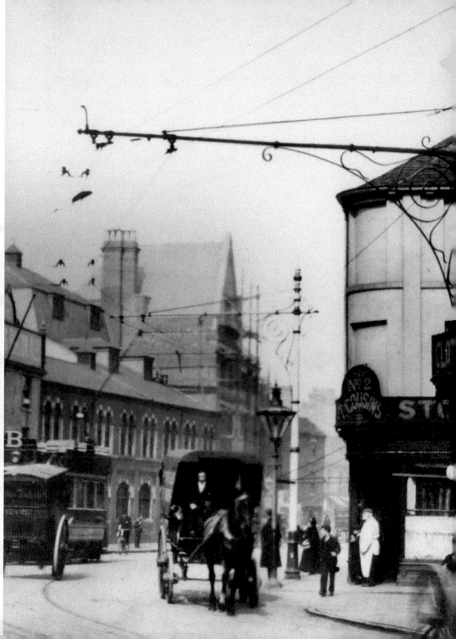

8. HULL PARAGON RAILWAY STATION

Paragon station and the adjacent Station Hotel, designed by railway architect G. T. Andrews, opened in 1848 to serve as the new Hull terminus for the growing traffic of the York & North Midland Railway (Y&NMR) leased to the Hull & Selby Railway (H&S). The station was also the terminus for the Hull–Scarborough line and from the 1860s the terminus of the Hull & Holderness and Hull & Hornsea railways.

The station and hotel were both built in the Italian Renaissance style, with both Doric and Ionic elements; the façades were inspired by the interior courtyard of the Palazzo Farnese in Rome. A £65,000 bronze statue of Philip Larkin by Martin Jennings was unveiled on the concourse of Hull Paragon Interchange on 2 December 2010, to mark the 25th anniversary of the poet's death. The statue is near to the entrance to the Station Hotel, a place often patronised by Larkin and immortalised by his 'Friday Night in the Royal Station Hotel'.

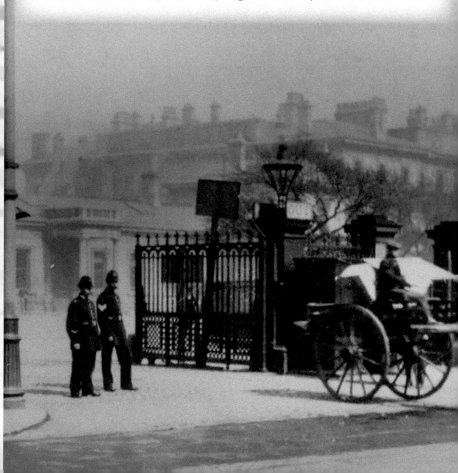

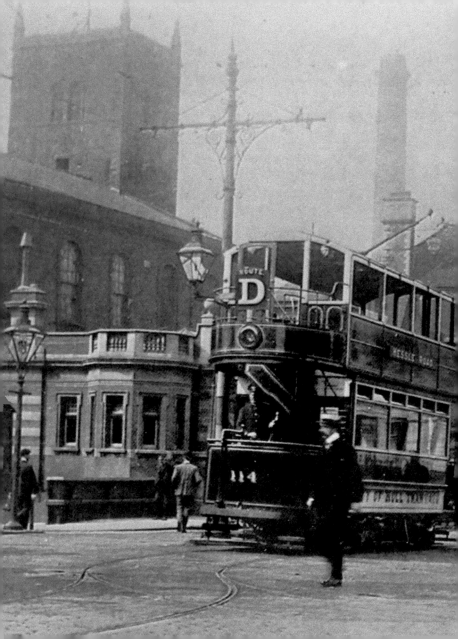

9. ST JOHN STREET

This is St John Street *c.* 1905, the terminus for electric trams 'D' (Dairycoates) and 'A' (Anlaby Road). On the left is St John's Church, built in 1791 and demolished around 1924. The Punch Hotel is visible just behind the tram, while in the background Willis's store can be seen. Behind the tram on the left the tall chimney of Hull electric tram's electricity generating station in Osbourne Street can be seen. The Ferens art gallery now stands on the site where St John's Church stood. The Punch Hotel remains a pub, but the old Willis's store was demolished and a new building was built on the site. Its name was changed to Willis Ludlow. The store is now Primark and forms part of the Princes Quay shopping centre, which opened in 1991.

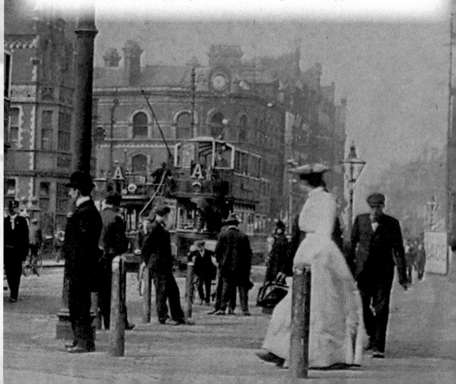

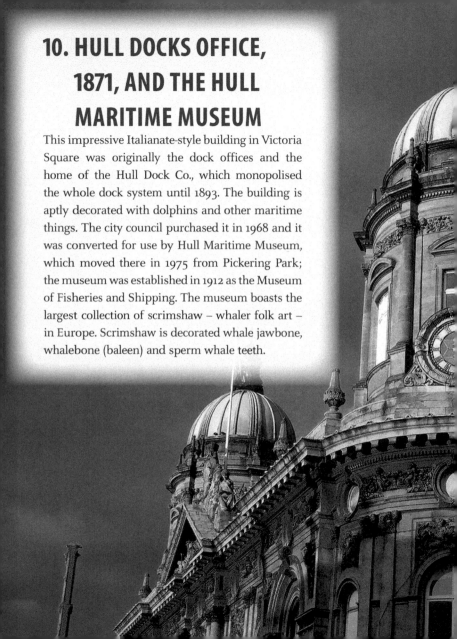

10. HULL DOCKS OFFICE, 1871, AND THE HULL MARITIME MUSEUM

This impressive Italianate-style building in Victoria Square was originally the dock offices and the home of the Hull Dock Co., which monopolised the whole dock system until 1893. The building is aptly decorated with dolphins and other maritime things. The city council purchased it in 1968 and it was converted for use by Hull Maritime Museum, which moved there in 1975 from Pickering Park; the museum was established in 1912 as the Museum of Fisheries and Shipping. The museum boasts the largest collection of scrimshaw – whaler folk art – in Europe. Scrimshaw is decorated whale jawbone, whalebone (baleen) and sperm whale teeth.

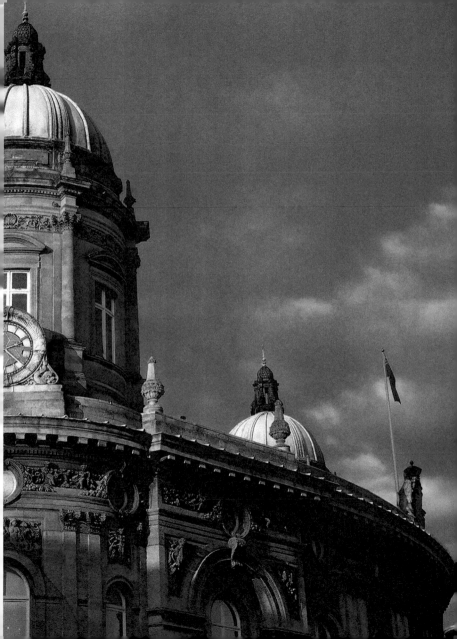

11. HULL AND EAST RIDING MUSEUM

What is now the Hull and East Riding Museum – the former Corn Exchange at No. 36 High Street – was originally a Customs House where customs and excise officers assessed cargoes for the payment of duties – Hull had a reputation for not paying custom and excise duties. Striking features of the building include the bearded mask over the arch, which is supported by impressive Corinthian columns. In 1923 the building opened as a museum of commerce and transport, eventually becoming the Hull and East Riding Museum in 1991. The picture shows a breathtaking Roman mosaic lifted from Horkstow in North Lincolnshire, the only surviving Roman chariot mosaic in Britain.

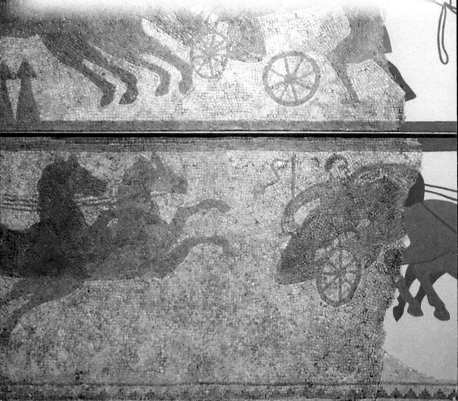

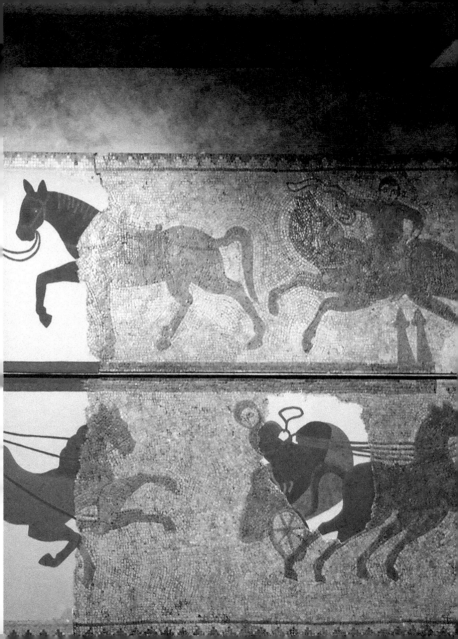

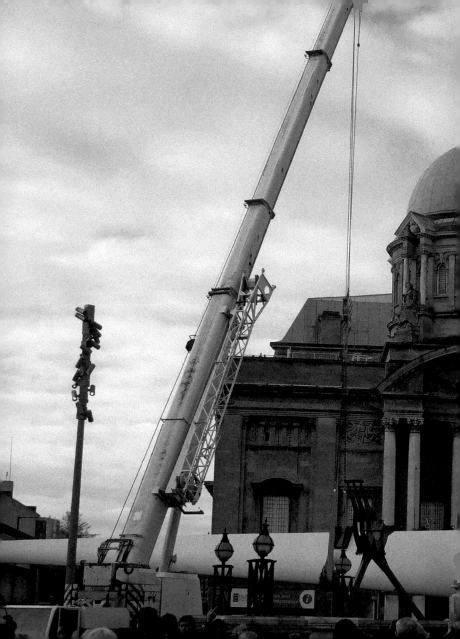

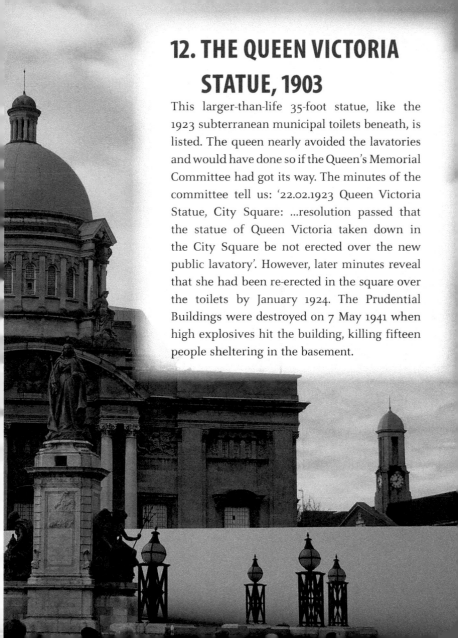

12. THE QUEEN VICTORIA STATUE, 1903

This larger-than-life 35-foot statue, like the 1923 subterranean municipal toilets beneath, is listed. The queen nearly avoided the lavatories and would have done so if the Queen's Memorial Committee had got its way. The minutes of the committee tell us: '22.02.1923 Queen Victoria Statue, City Square: ...resolution passed that the statue of Queen Victoria taken down in the City Square be not erected over the new public lavatory'. However, later minutes reveal that she had been re-erected in the square over the toilets by January 1924. The Prudential Buildings were destroyed on 7 May 1941 when high explosives hit the building, killing fifteen people sheltering in the basement.

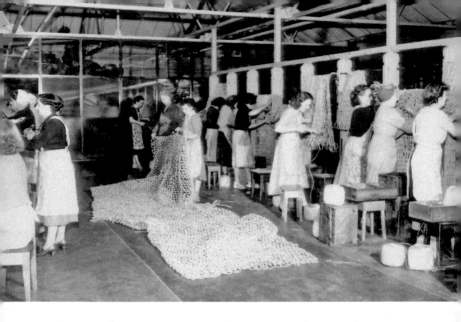

13. THE DOCKS

The Haven (Old Harbour) is the lower part of the River Hull as it flows toward the Humber. From the earliest days this was the main assembly point for vessels loading and unloading their cargoes, but as the numbers of boats increased in volume and size, the busy waterway became overcrowded. To cater for this the first enclosed dock was completed in 1778, although its excavation necessitated the removal of the northern section of the city's walls. This was followed by the Humber Dock in 1809 and the Junction Dock (Princes Dock) in 1829. The series of docks followed the line of the old city walls, which were removed. The picture shows Hull women making fishing nets.

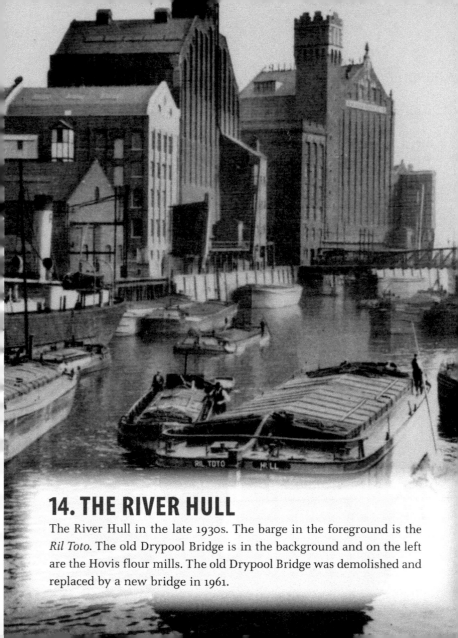

14. THE RIVER HULL

The River Hull in the late 1930s. The barge in the foreground is the *Ril Toto*. The old Drypool Bridge is in the background and on the left are the Hovis flour mills. The old Drypool Bridge was demolished and replaced by a new bridge in 1961.

15. THE BLADE, 2017

In January 2017 a truly unique structure came to Queen Victoria Square as a gift from Siemens to form part of Hull's role as UK City of Culture. Transporting the huge wind turbine blade from the Siemens Alexandra Dock factory to the city centre was a massive logistical exercise: the blade measures 75 metres in length and is 3.5 metres wide at its base, or 'root', and it weighs 25 tons. However, due to Siemens' unique manufacturing this blade is actually 20 per cent lighter than a traditionally engineered offshore wind turbine blade. The blade was mounted 5.5 metres from the ground at its highest point, allowing buses to pass underneath. On 18 March 2017 the blade returned to the Siemens site on Alexandra Dock.

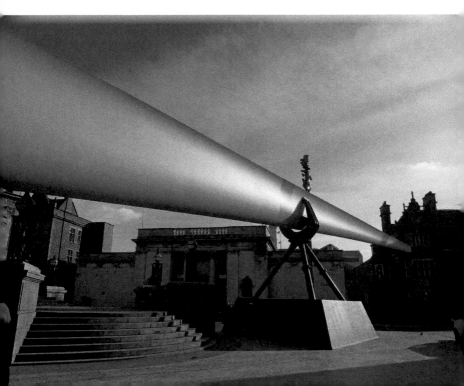

16. THE EMPRESS

A striking façade, floral and florid. The Empress is a fine-looking former Queen's dockside pub looking out on Queens Gardens. It was originally aptly called The Dockside Tavern in 1790, or just plain Dock, and then The Old Dock Tavern, refreshing those working on the nearby Queen's Dock. Toilets were in the building next door. The size and shape can be accounted for by the fact that the building was originally a dockside warehouse. We have a German landlord to thank for the name change in 1876: Herr Westeroff, obviously keen to cement national ties with the monarch, successfully applied to change the name to The Empress (of India) with the proviso that he remained closed on Sundays.

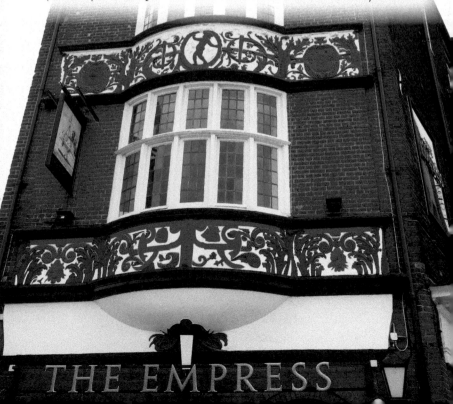

THE EMPRESS

17. THE DEEP

The Deep is without doubt one of the world's best and most spectacular aquariums. No fewer than 3,500 fish can be seen swimming about here, including seven magnificent species of sharks, rays and northern Europe's only pair of green sawfish, along with fish that glow in the dark, coral, turtles, jellyfish, frogs, penguins, a flooded Amazon forest and numerous species of insects. Marine life apart, the tanks contain 2,500,000 litres of water and 87 tons of salt. The Deep is the world's only submarium – a building that is partly submerged in the water that surrounds it. (Photo © Skyrider 2688 under Creative Commons 4.0)

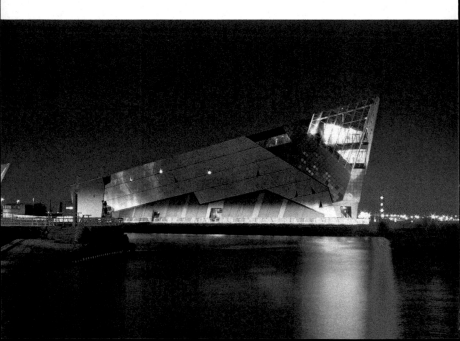

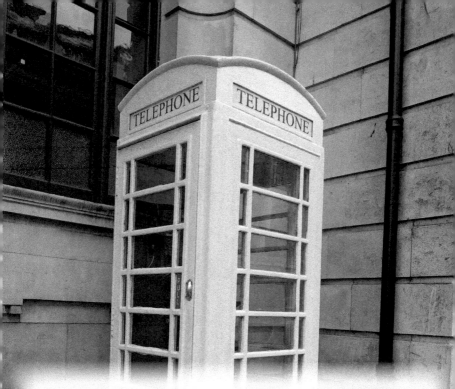

18. THE HULL TELEPHONE BOX, 1904

Until 2007 Hull was the only city in the UK to have maintained an independent, municipal telephone network provider operating under the name of Hull Telephone Department. Now it is privatised as KCOM, once known as Kingston Communications, founded in 1902. KCOM have retained 125 or so K6s, which are still in use today – the company allocated approximately 1,000 for sale to the public. So, in Hull you will see distinctive cream phone boxes, not red ones. The distinctive cream telephone boxes are quintessentially Hull, highly symbolic locally, communicating to visitors the proud independence that characterises the city and its citizens.

19. TOWN DOCK OFFICES AND MONUMENT BRIDGE

The building with the three domes is the Dock Offices. It was built between 1867 and 1871 on land alongside Queen's Dock. In the foreground is the entrance to Queen's Dock and the original Monument Bridge. On the left of the Dock Offices is the Prudential building, built around 1903. The road running alongside is Waterworks Street. The City Hall is yet to be built, only completed in 1909/10. Other streets demolished, as can be seen in this photograph taken from St John's Street, include Engine Street, Junction Street and Waterworks Street, which were demolished to create Queen Victoria Square. William Wilberforce's Monument is also clearly visible.

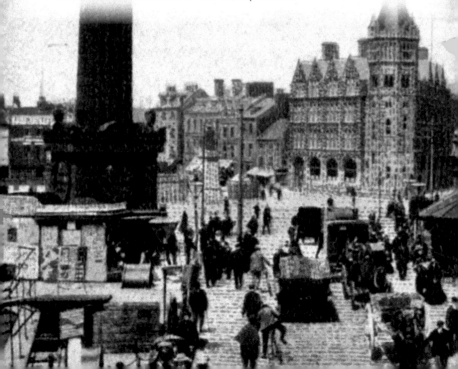

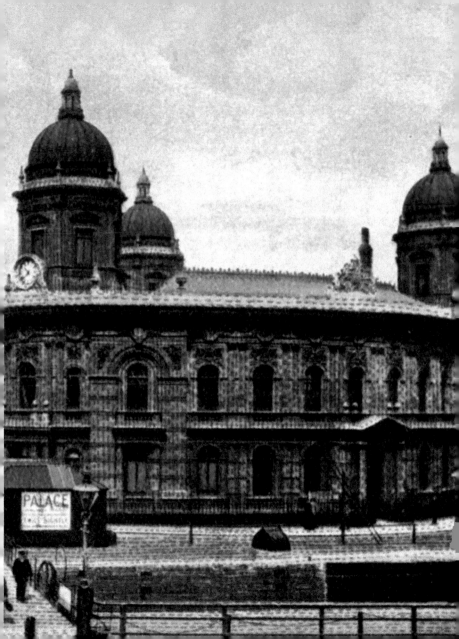

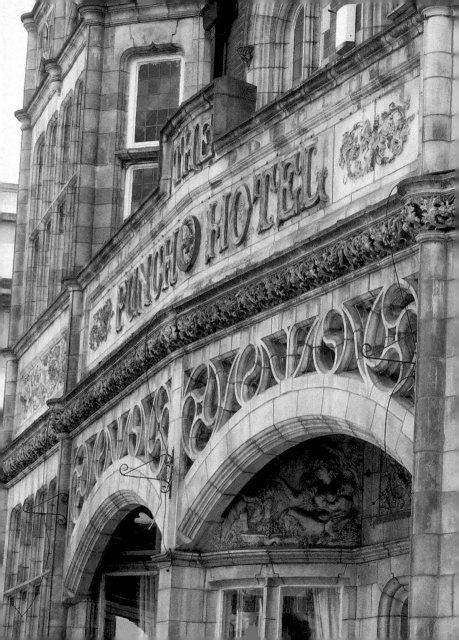

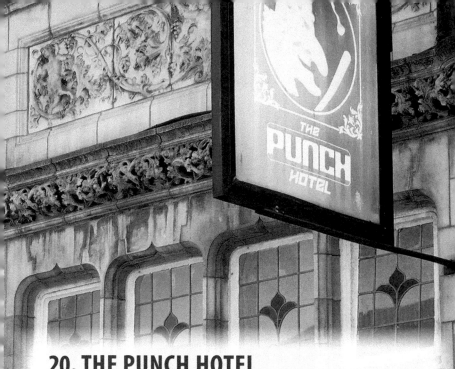

20. THE PUNCH HOTEL,
QUEEN VICTORIA SQUARE

This extremely ornate Victorian building is not the original. The first Punch was built in 1845 facing Waterhouse Lane at the rear of the present Punch Hotel in Queen Victoria Square, some of which is now under the entrance to the Princes Quay shopping complex. The redevelopment of St John Street and Waterworks Street in 1894–95 saw the old Punch demolished and rebuilt by the Hull Brewery Co. in the new square. The elaborate façade of terracotta and magnificent Burmantoft's faience was designed by Smith, Broderick and Lowther. The Grade II-listed building is regarded by many as an architectural masterpiece. The ceiling is particularly special.

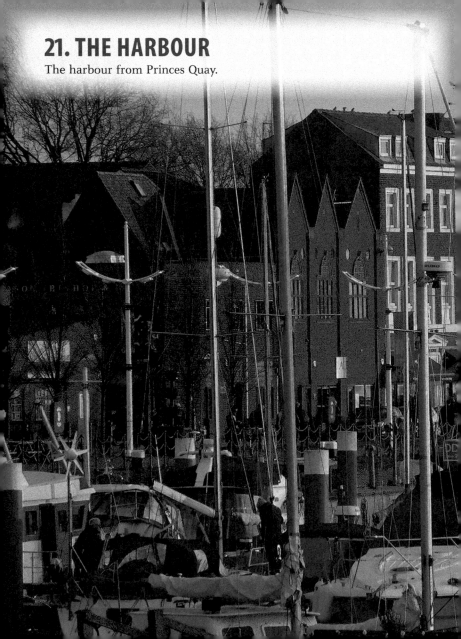

21. THE HARBOUR

The harbour from Princes Quay.

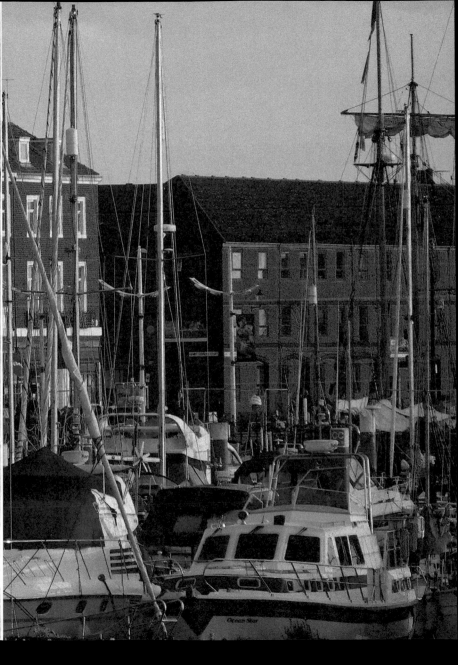

22. BURTON'S STORE, WHITEFRIARGATE

Looking across Monument Bridge, which was originally called Junction Bridge (the dock is just visible on the right). It was later changed to Monument Bridge. On the left of the photograph the new Burton's menswear shop can be seen. On the right of the photograph are Monument buildings, built in 1908, and Bridge Chambers, built in 1914. The street just visible on the right is Prince's Dock Street. Note the old-style telephone boxes behind the car.

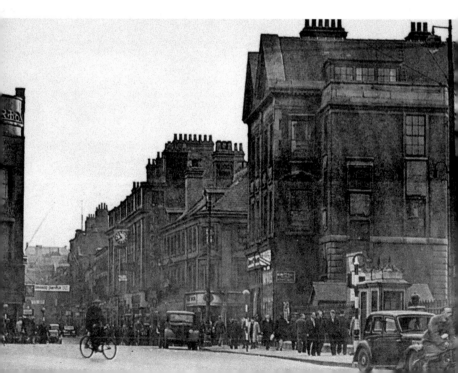

23. HIGH STREET

Many of the original buildings here date from the fourteenth century. Most were timber framed, as was the building on the right. On the left is the George & Dragon coaching inn. William Wilberforce was born further down High Street. All the buildings in the photograph have long been demolished.

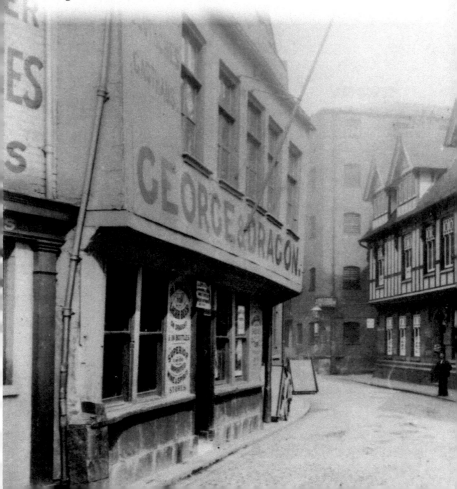

24. WILBERFORCE HOUSE, 1660

Wilberforce House at No. 25 High Street is Hull's oldest surviving museum. It opened in 1906 and takes its name from William Wilberforce, the abolitionist who was born here in 1759. The museum is dedicated to Wilberforce and his campaign to abolish the slave trade.

The building was originally built in the 1660s for one of the Listers, a family of Hull merchants. Sir John Lister entertained Charles I here on his first visit to Hull. In 1709 the house passed to John Thornton, a prominent exporter of cloth and lead at that time. One of Thornton's apprentices was William Wilberforce, who had moved to Hull from Beverley to work. This Wilberforce was the grandfather of the abolitionist, who married his master's daughter in 1711. The house passed to Wilberforce in 1732 while the family made their fortune in the Baltic trade.

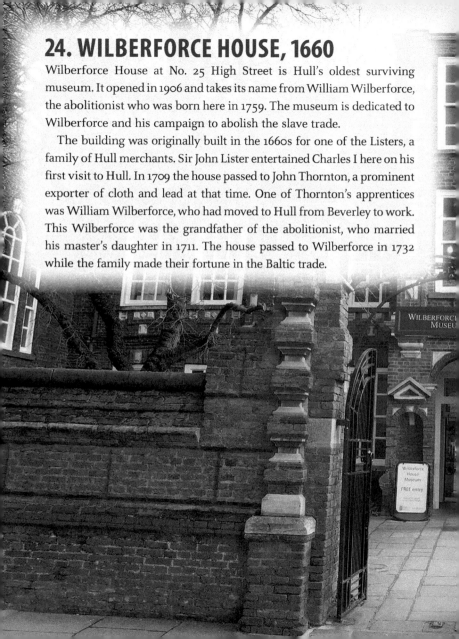

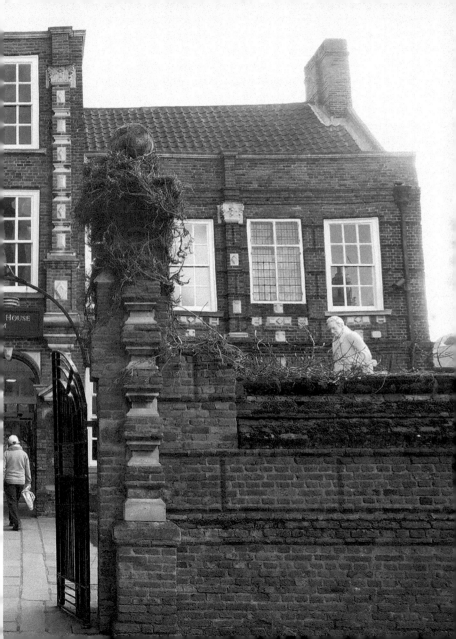

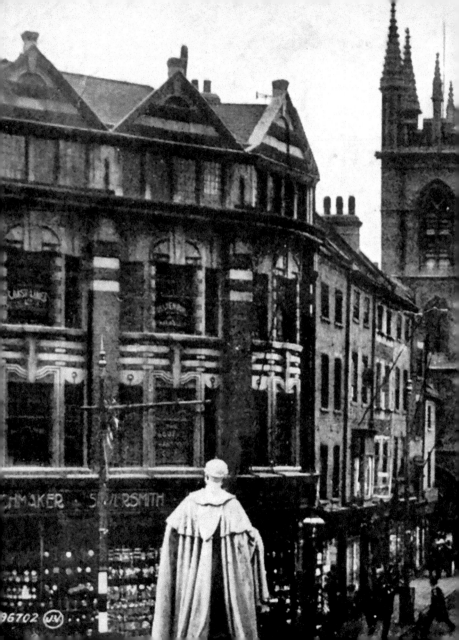

25. LOWGATE

The main General Post Office is on the right. This site was occupied by the manor house of Sir William de la Pole, who was the first mayor of Hull in 1331. It later became Suffolk Palace, and after it was seized by the Crown in 1504, it was called 'The Kings' Manor'. Looking down Lowgate towards Market Place you can see the imposing Holy Trinity Church, now minster. The General Post Office building is today apartments and a Wetherspoons public house, while the buildings on the left were demolished to make way for the Crown Courts.

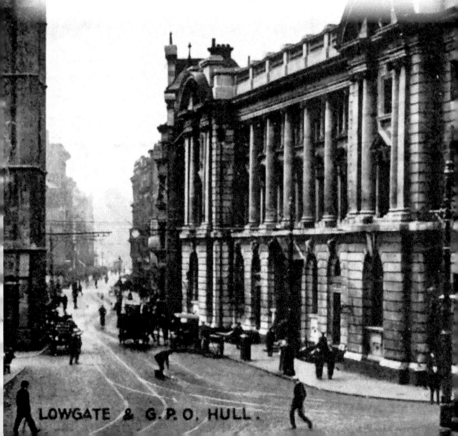

LOWGATE & G.P.O. HULL.

26. HOLY TRINITY

In June 1915 Zeppelins dropped a bomb nearby, and Holy Trinity was only saved by a change in wind direction and the fire services. In March 1916 windows were shattered during another raid: one window provides a reminder of that evening with a mosaic of glass made up from the damaged windows. During the Second World War, Holy Trinity served as an air-raid shelter, and was also a navigational marker for the German planes, which may account for its survival. Today, the north choir aisle is a memorial space for a number of military organisations and for Hull's trawlermen lost at sea. On 7 November 2016, Archbishop of York John Sentamu announced that Holy Trinity would be accorded minster status in a ceremony held on 13 May 2017.

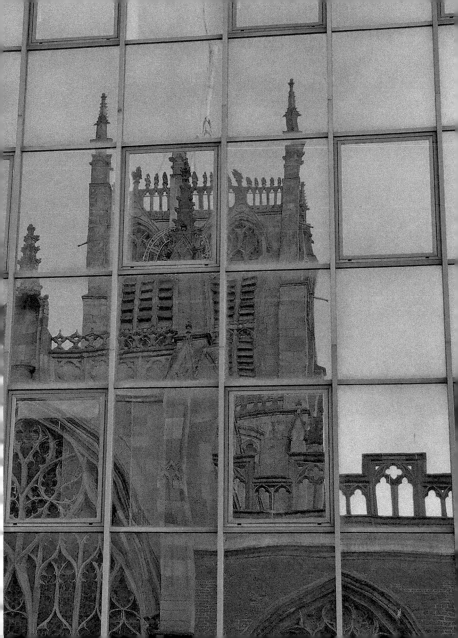

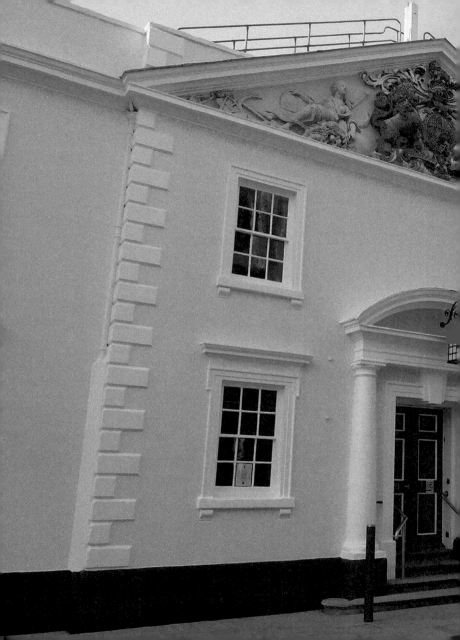

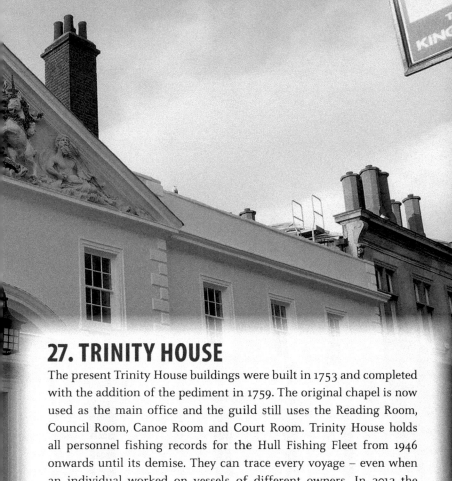

27. TRINITY HOUSE

The present Trinity House buildings were built in 1753 and completed with the addition of the pediment in 1759. The original chapel is now used as the main office and the guild still uses the Reading Room, Council Room, Canoe Room and Court Room. Trinity House holds all personnel fishing records for the Hull Fishing Fleet from 1946 onwards until its demise. They can trace every voyage – even when an individual worked on vessels of different owners. In 2012 the school was made into an academy, and the site of the old school is now an events area called Zebedee's Yard. In 2013 the school moved to George Street, into the refurbished Nautical College Building, a former university building, the Derek Crothall building, which was part of the University of Lincoln.

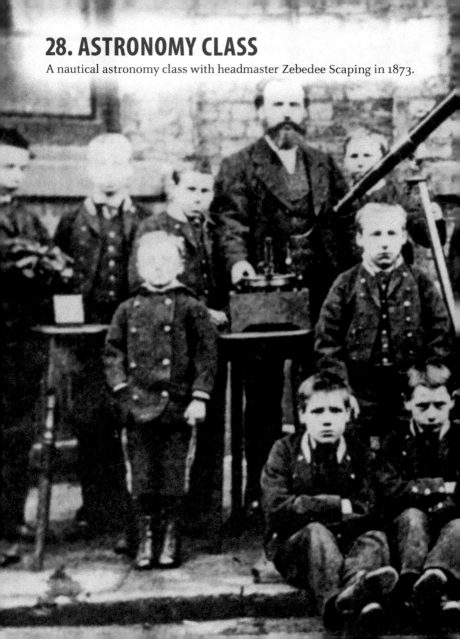

28. ASTRONOMY CLASS

A nautical astronomy class with headmaster Zebedee Scaping in 1873.

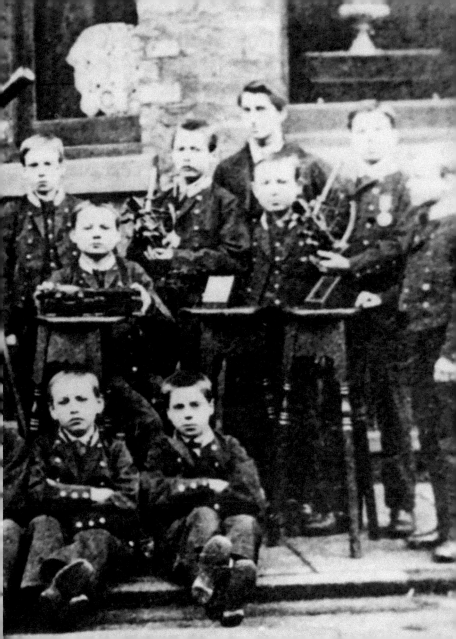

29. PUBLIC TOILETS, NELSON STREET, 1902

These public toilets are among the best in Hull with a reputation extending back to 1902. These award-winning public lavatories are, according to the *Hull Daily Mail*, 'hailed as a shrine to sanitation, with generous displays of potted plants, gleaming cream tiles and polished brass, this is a fine place to "spend a penny"'. Lord Nelson would have been very proud.

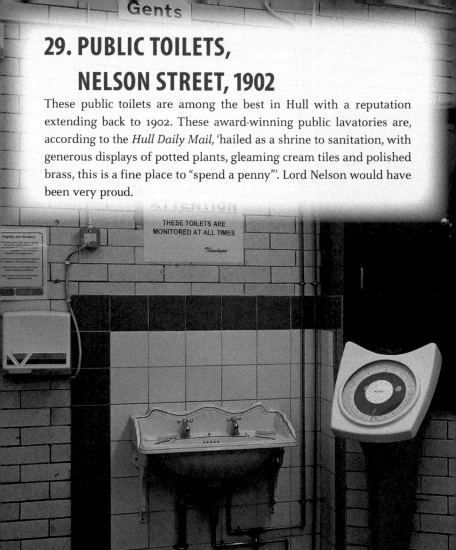

30. NEEDLER'S, SCULCOATES LANE, 1886

Needler's can trace its history back to 1886 when a young man by the name of Frederick Needler, of Skirlaugh, started the sweet company. With a factory in Spring Street, he grew the company to the point where it produced 650 tons of chocolate and 1,500 tons of sweets in a year. However, when the 1930s depression hit, the company floundered. Needler's needed a new way to compete against the other confectionery giants it was up against, such as Cadbury and Rowntree, and in 1938 it found one. Food chemists at Needler's discovered a way of producing clear fruit drops and sales shot up dramatically. The company stayed in business until 2002 when it was acquired by Ashbury Confectionery.

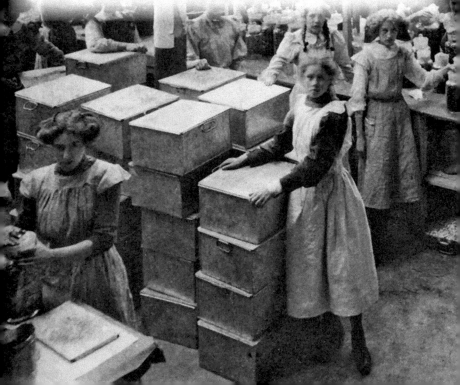

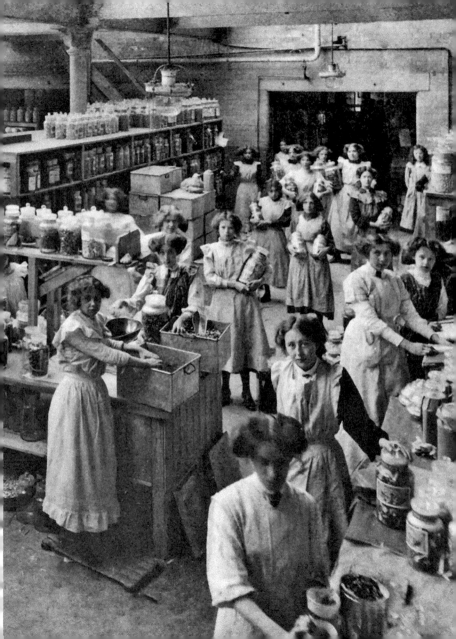

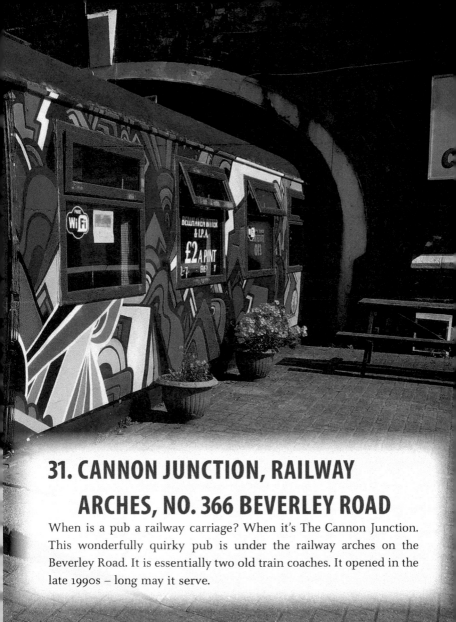

31. CANNON JUNCTION, RAILWAY ARCHES, NO. 366 BEVERLEY ROAD

When is a pub a railway carriage? When it's The Cannon Junction. This wonderfully quirky pub is under the railway arches on the Beverley Road. It is essentially two old train coaches. It opened in the late 1990s – long may it serve.

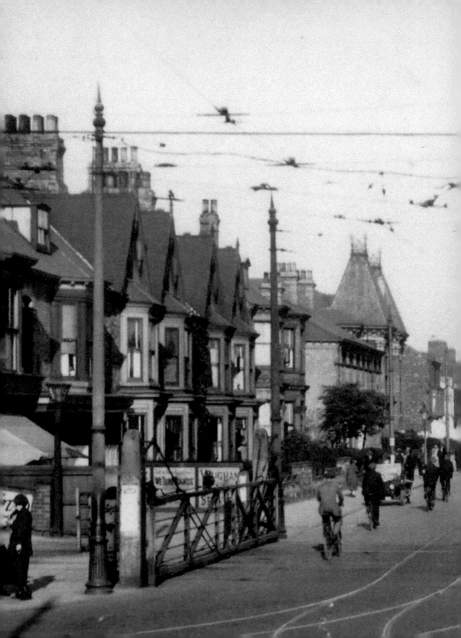

32. SPRING BANK

A fully enclosed electric tram on the 'S' service is on Spring Bank looking towards the city centre. Derringham Street is on the right with the Polar Bear public house and the Botanic Hotel visible on the right. The Botanic level crossings are in the foreground.

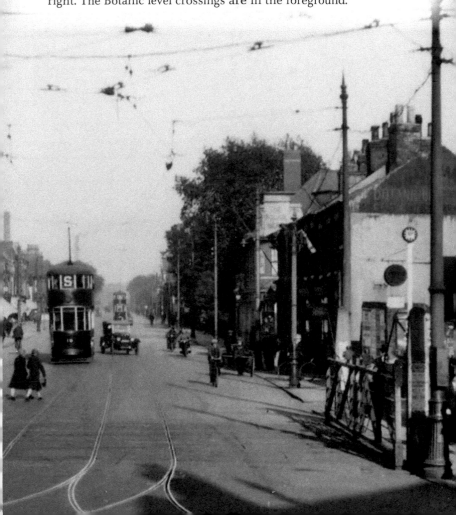

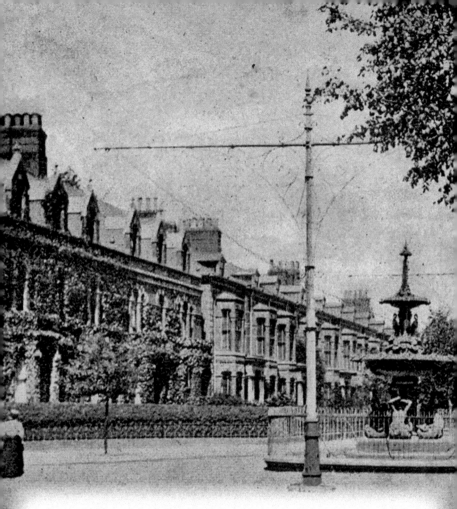

33. PRINCES AVENUE

Princes Avenue was once known as Mucky Peg Lane after the ankle-deep mud that had to be negotiated. However, there is a Mucky Peg Lane in York that is reputedly named after a lady of ill repute...

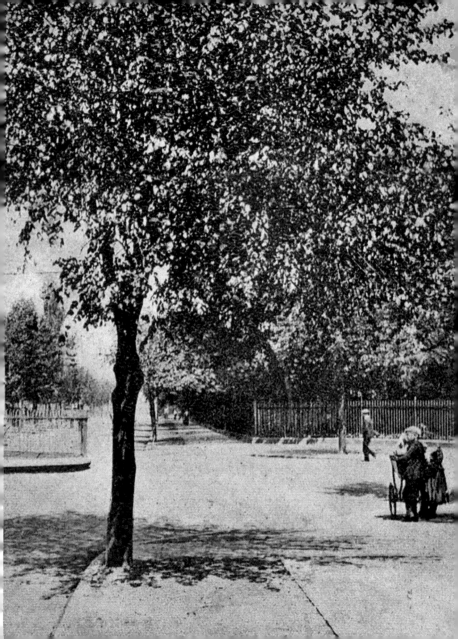

34. PRINCES AVENUE

This is a *c.* 1905 photograph looking up Princes Avenue from the junction with Spring Bank. The old cemetery is on the left while Botanic railway station is on the right.

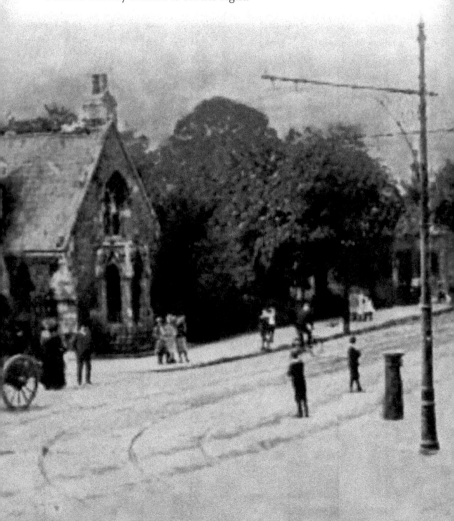

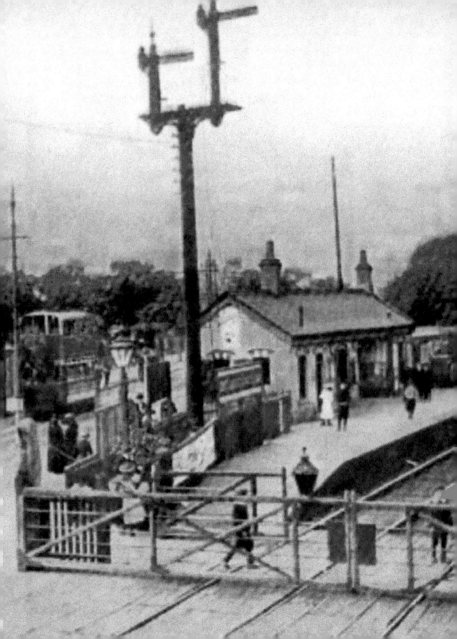

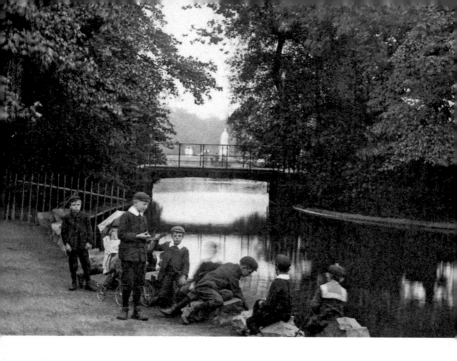

35. PEARSON PARK, 1860

Pearson Park lies between Princes Avenue and Beverley Road and 'still resonates with Victorian grandeur'. Philip Larkin lived in a house, No. 32, overlooking Pearson Park, from 1956 to 1974. Originally known as the People's Park, it was the first public park to be opened in Hull. The picture shows Edwardian boys in 1908 up to no good.

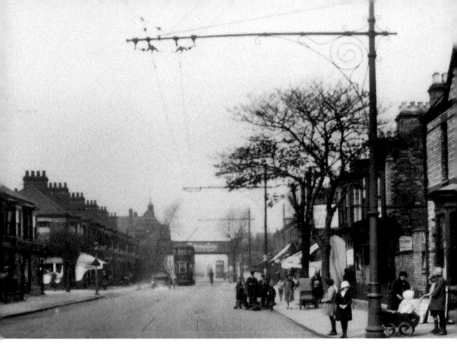

36. NEWLAND AVENUE

Ella Street is on the left of the photograph. Newland Avenue was built
in the 1880s and still bustles today.

37. SAILORS' ORPHAN HOMES, 1867

This wonderful society was born in 1821 when a meeting was held in St Mary's Boy's schoolroom in Salthouse Lane, initially to help veterans of the Napoleonic Wars. The Port of Hull Society for the Religious Instruction to Seamen was thus founded and a floating chapel, *Valiant,* opened for worship in the Humber Dock.

In 1837 the society started to reach out to families, particularly children. The Sailors' Orphan Institute was established in Waterhouse Lane for clothing and educating children of deceased seamen

Sailors' Orphan Homes, Newland.

and rivermen. In 1892, the society bought 6 acres at Newland on Cottingham Road on which to erect purpose-built cottages. From 1895 up to twenty-five orphans lived in each of the ten cottages under the care of a house mother. A school, assembly and dining hall and sanatorium completed the model village. A swimming pool was added in 1921. The name was changed to the Sailors' Childrens' Society, which continues to assist the dependants of Royal and Merchant Navy personnel and fishermen's families at Francis Reckitt House in Newland.

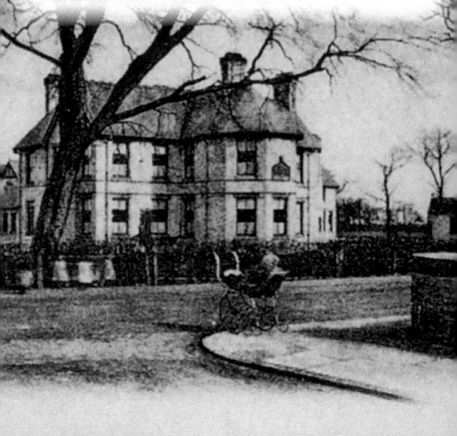

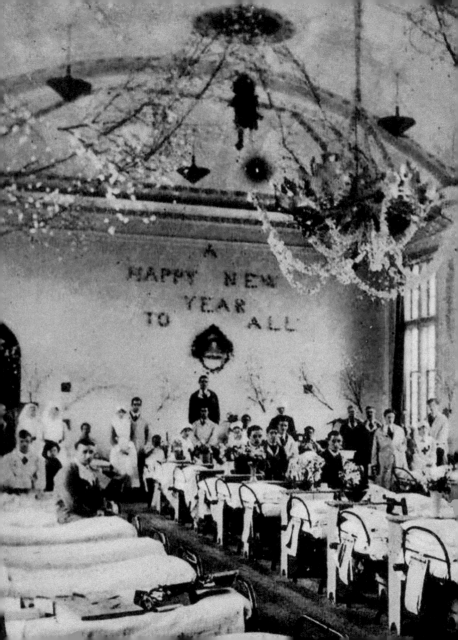

38. NEWLAND SCHOOL FOR GIRLS

In 1914, with England at war, the school on Cottingham Road was requisitioned for use as a military hospital. Headmistress Miss Rowland, members of the staff and the girls were voluntary helpers at the hospital. The hospital was visited by George V and Queen Mary in 1917. This view of one of the wards was taken in December 1918, just after the armistice.

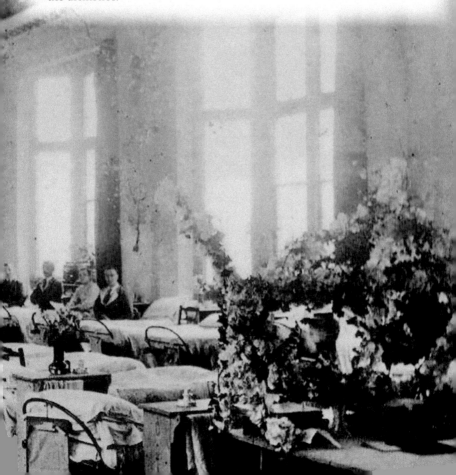

39. THE BRYNMOR JONES LIBRARY, UNIVERSITY OF HULL, 1970

The imposing Brynmor Jones Library at the University of Hull contains over 1 million volumes. In 1967 it was named after Sir Brynmor Jones, a pioneer in research in liquid crystals at Hull, head of the Department of Chemistry in the 1930s and vice-chancellor of the university from 1956 to 1972. The library really consists of two main parts: the older art deco-style entrance and five-floor front section from the 1950s, and the more recent extension, completed in 1970, which comprises eight floors and a basement. Philip Larkin was librarian here from 1955 until his death in 1985.

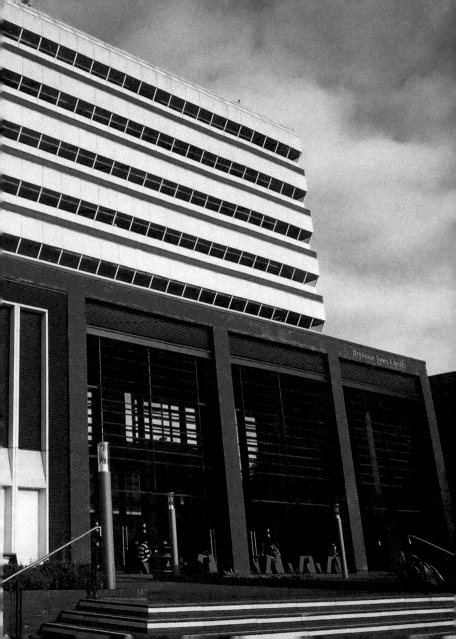

40. JOHNNY MAC, HULL UNIVERSITY UNION, UNIVERSITY HOUSE, UNIVERSITY OF HULL

This union bar is named after Beirut hostage John McCarthy CBE, DLitt (American Studies, 1979). Other alumni who would have graced the bar include Jill Morell, McCarthy's determined lifeline and tireless champion back in London and founder of Friends of John McCarthy (FOJM); musicians Tracey Thorn and Ben Watt (Everything but the Girl); film director Anthony Minghella; poet Roger McGough; TV presenter Sarah Greene (*Blue Peter, Going Live*); Labour politicians John Prescott, Frank Field, and Roy Hattersley; Jenni Murray of *Woman's Hour*; and Radio 1 presenter Mark Chapman. McCarthy was a journalist working on a two-month posting with the WTN news agency at the time of his kidnap by Islamic Jihad terrorists in Lebanon in April 1986. He was returning from the assignment in Beirut when he was kidnapped on the way to the airport and was held in captivity until his release on 8 August 1991.

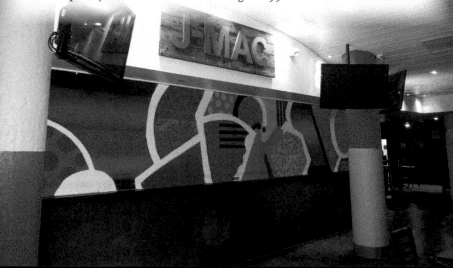

41. COTTINGHAM ROAD

With fields on either side of Cottingham Road, it has a very rural look to it in the 1930s. The drain can be seen on the right, as can the Good Fellowship Inn, built in 1928.

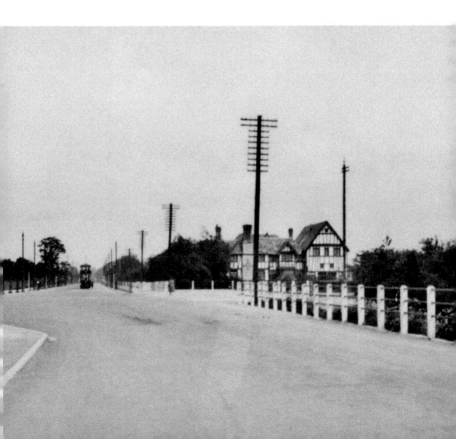

42. NORTH BRIDGE

North Bridge was opened in 1931, replacing an earlier bridge of 1870. This has always been an important bridge linking the city centre with Holderness Road, east Hull and the eastern suburbs and villages.

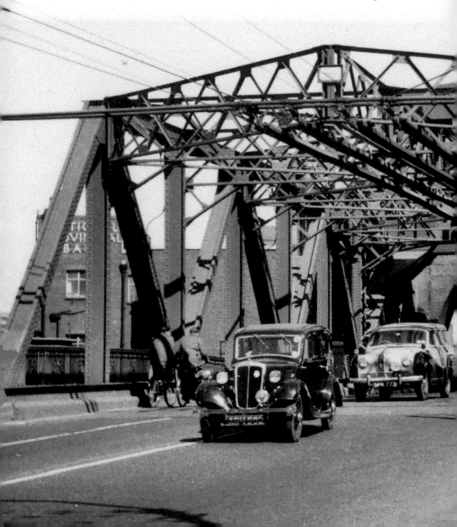

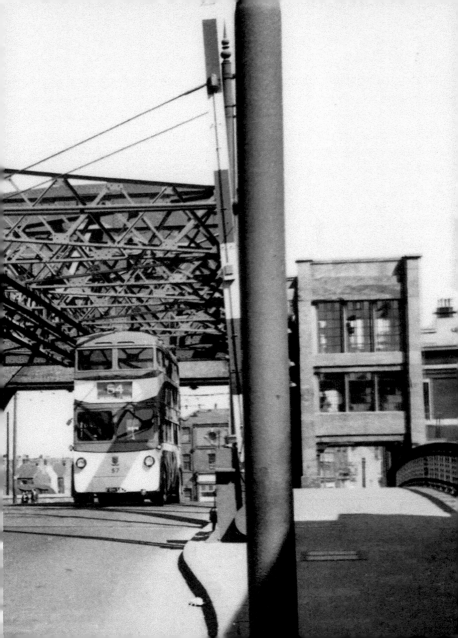

43. RECKITT & SONS LTD, DANSOM LANE

The name Reckitt & Sons, of Dansom Lane, is probably less well known than some of its staple household products, which include Brasso, Nurofen and a variant of the chemical developed by Joseph Lister (after whom Listerine was named) in 1932 to make the famous medical profession-endorsed germicide we know as Dettol.

In 1840 Isaac Reckitt founded the firm that was to become Reckitt & Colman, a global leader in household, toiletry, food and pharmaceutical products. Starting with a mere twenty-five employees, the company now employs more than 25,000 people worldwide.

The photo shows some serious bomb damage at the Kingston Works on 19 July 1941.

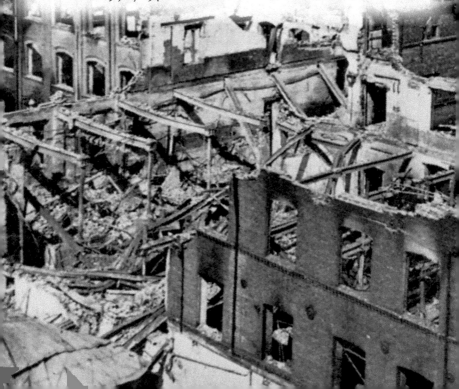

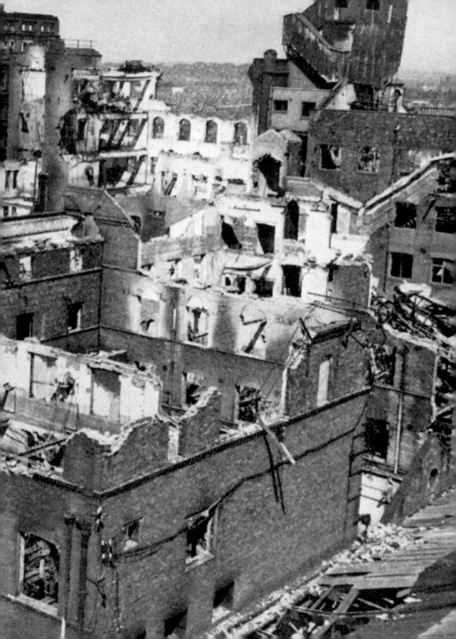

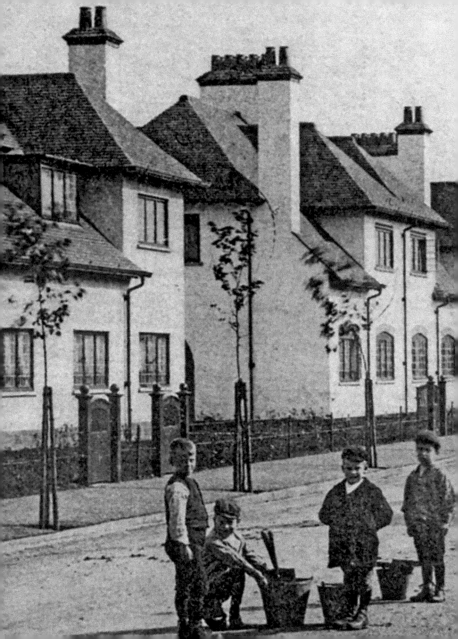

44. THE RECKITT MODEL VILLAGE, 1908

The deeds for the village are dated 23 December 1907. The Garden Village was the realisation of Quaker Sir James Reckitt's wish to improve the domestic and social circumstances of the workers at his household products, disinfectants and pharmaceuticals factory in Dansom Lane.

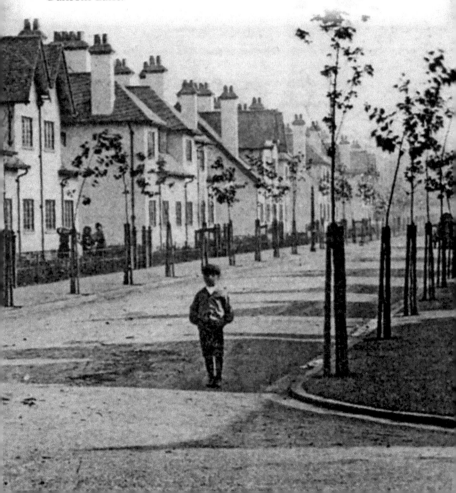

45. MORTON'S GROCERY SHOP

Thirty-one-year-old Eddie Morton was in bed as usual above his grocer's shop on the night of 18 August 1941 when another air raid started. A bomb exploded on his shop blowing him into Beech Avenue.

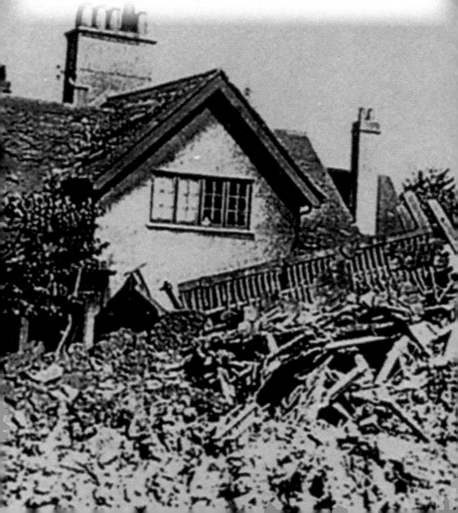

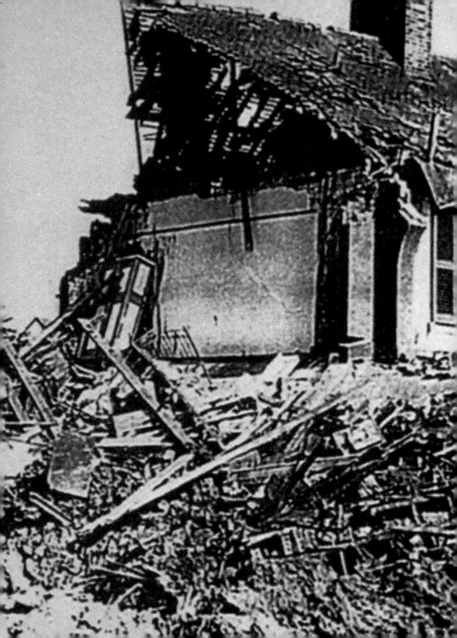

46. THE GARDEN VILLAGE

Sir James summed up his vision in February 1907 when he wrote to general manager, later director, T. R. Ferens MP:

Whilst I and my family are living in beautiful houses, surrounded by lovely gardens and fine scenery, the workpeople we employ are, many of them, living in squalor, and all of them without gardens in narrow streets and alleys ... the time has come ... to establish a Garden Village, within a reasonable distance of our Works, so that those who are wishful might have the opportunity of living in a better house, with a garden, for the same rent that they now pay for a house in Hull with the advantages of fresher air, and such Clubs, and outdoor amusements, as are usually found in rural surroundings. The outlay would gradually be very large, but some revenue would be derived from rents.

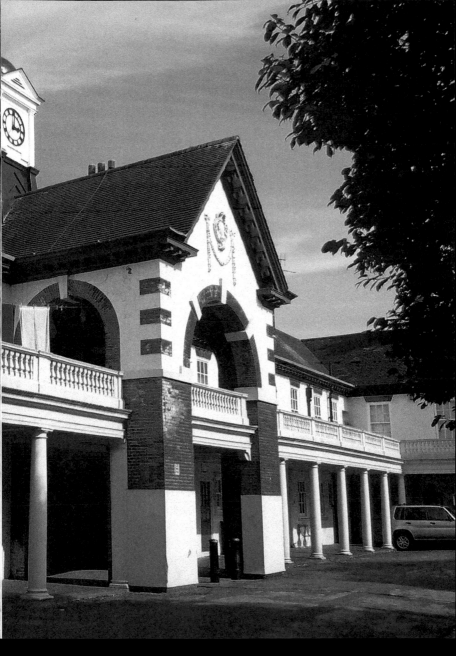

47. CARNEGIE FREE LIBRARY

Now known as the Carnegie Heritage Centre, the Carnegie Free Library opened in 1905 and became Hull's fifth branch library. It was financed by the Scottish-American industrialist and philanthropist Andrew Carnegie and was one of the 3,000 Carnegie libraries he set up in the UK, USA and countries in what was then the British Empire. The first in the UK was opened in 1883 in his home town of Dunfermline. The deal was that Carnegie would build and equip the libraries, but only on condition that the local authority matched that cost by providing the land and a budget for operation and maintenance. Typically they comprised a lending library, reference library and newspaper reading room.

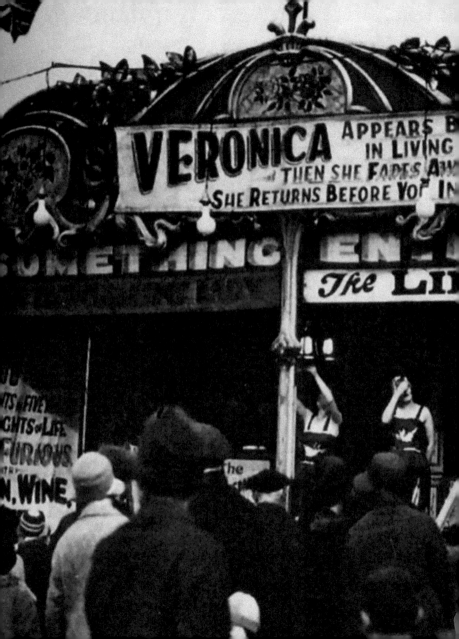

48. HULL FAIR

The fair, now one of Europe's largest and oldest travelling funfairs, has, twentieth-century war years apart, been coming to the city since 1278 and parks up in Walton Street car park (since 1888), next to West Park and the KC Stadium every year for a week in October. It all started in 1279 when Meaux Abbey was granted an annual fair in Wyke-upon-Hull around the feast of Holy Trinity and for the next twelve days. In the eighteenth and early nineteenth centuries the fair featured jugglers, theatrical booths, puppet shows and the famous Bostock and Wombwell's Menagerie, which gave many of the people of Hull their first experience of wild and exotic animals. Less palatable to us today were the freak shows in which disabled, deformed and fat people were exhibited along with hermaphrodites, dwarfs and giants. In 1815 William Bradley, the Yorkshire giant from Market Weighton, drew in the crowds. In the 1870s mechanisation gave Hull Fair a new lease of life with the introduction of steam-powered carousels, ferris wheels, waltzers, ghost trains ... and speed.

49. THE LAWNS, COTTINGHAM, 1963

The Lawns is where nearly 1,000 University of Hull students live in leafy Cottingham. It comprises seven halls of residence (Ferens, Lambert, Nicholson, Morgan, Downs, Reckitt and Grant) and the Lawns Centre – the catering and social hub. The halls are set in 40 acres of 'landscaped parkland'. There is a police station at the main entrance but this is not believed to be a reflection on the behaviour of the students.

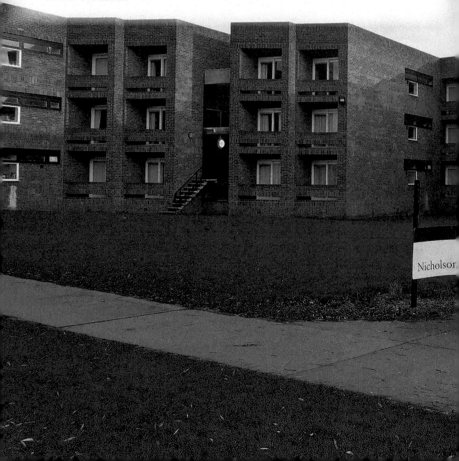

Nicholson

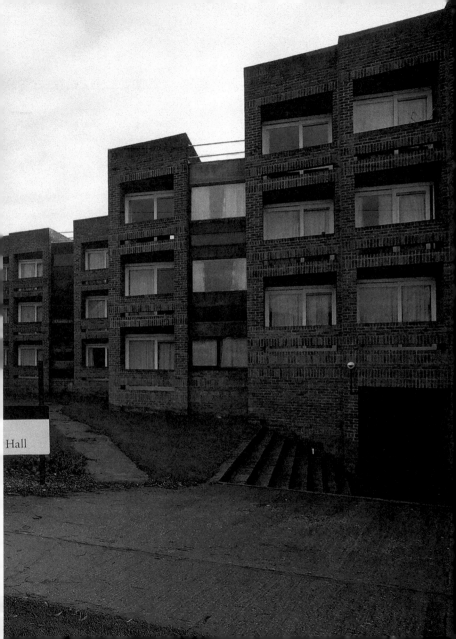
Hall

50. BROOK STREET AND ANLABY ROAD

In their later years the electric trams were enclosed, although the motorman and the stairs were still in the open, as seen on this tram on the 'D' service to Dairycoates. There is a similar tram in the background on the 'A' service to Anlaby Road, *c.* 1910. This photograph was taken before the new Ferensway was built, looking down Anlaby Road and Carr Lane. The City Hall is in the background.

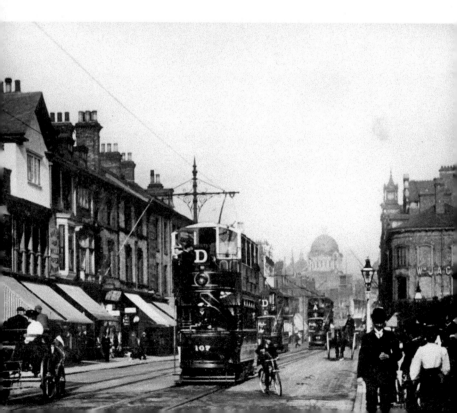

51. DAIRYCOATES

Dairycoates *c.* 1907. On the right we see a horse bus on its way to Hessle. In the centre of the photograph is an electric open-top tram on the 'D' service, ready for the return journey back to the city centre. Also on the right is Pichersgills stores, at No. 624 Hessle Road. At this time the electric trams terminated at Hawthorne Avenue. The electric tramway down Hessle Road commenced on 5 July 1899 and was not withdrawn until 30 June 1945.

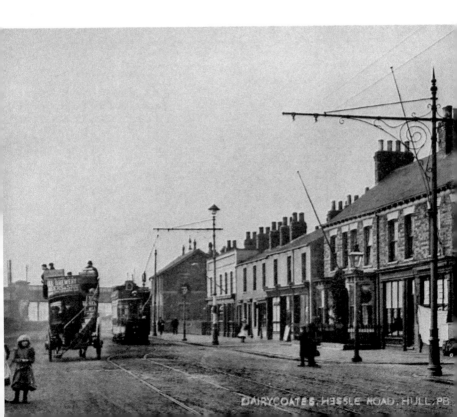

DAIRYCOATES, HESSLE ROAD, HULL. PB.

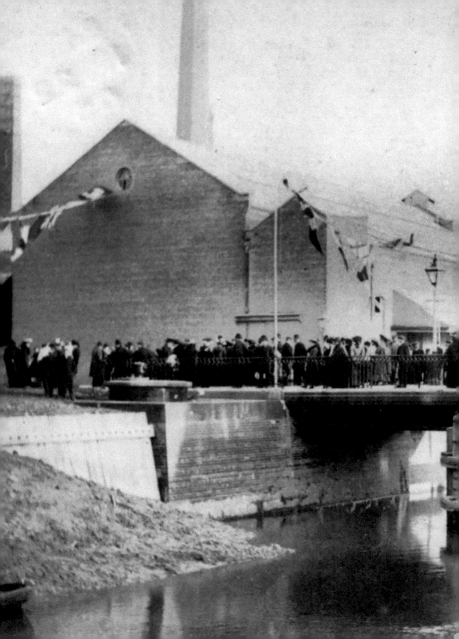

52. STONEFERRY BRIDGE

Before the bridge, if you wanted to cross the River Hull at Stoneferry you had to catch a ferry. The Stoneferry Bridge was opened in 1905. Here a large crowd has gathered for the opening of the bridge. This bridge, although adequate for horse-pulled carts, was far too narrow for modern-day traffic. The old bridge lasted for eighty-six years before it was replaced by a new bridge.

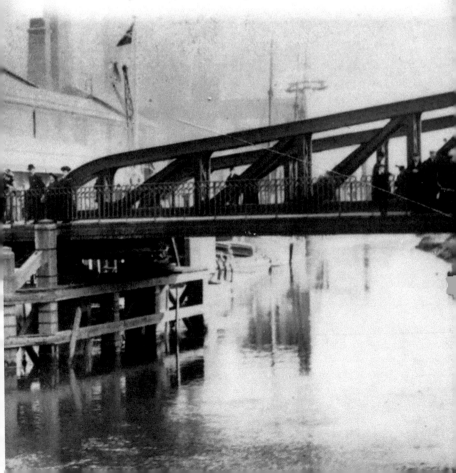

ACKNOWLEDGEMENTS

A number of the photographs and images in this book have been made available by a various individuals and organisations. The book would be considerably diminished without their generosity and so it gives me pleasure to thank the following: Steve West and Gordon Stephenson at Reckitt Benckiser Heritage, Hull; I am indebted to J. W. Houlton's *History of the Garden Village Area* for much of the information on the Reckitt Village – it remains unpublished but a copy resides in the Reckitt-Benckiser archive and can be read on The Garden Village Society website: *www.gardenvillagehull.co.uk;* Raymond Needler gave permission to use images and information originally published in his definitive *Needlers of Hull*; and finally, many thanks to Brian Miles, brother of Philip Miles, the late author of *Hull Through Time*. All the modern photography is by the author unless indicated otherwise.